Swear Word Questions Guys Ask On A First Date Adult Coloring Book

Woodrow Guy

All Rights reserved. No part of this book may be reproduced or used in any way or form or by any means whether electronic or mechanical, this means that you cannot record or photocopy any material ideas or tips that are provided in this book.

© 2016 The Garvin Company

Check out our website for our full selection of our Adult Creations
www.woodrowguy.com

This is a Bleed Through Page If You Are Using a Coloring Marker or Pen!
Find Other Great Titles By Us. Search on Your Favorite Book Retailer
Just search for the author name of Woodrow Guy .
He also Publishes Lite Erotica on Amazon Kindle
CHECK OUT OUR WEBSITE FOR ALL OUR ADULT CREATIONS
WWW.WOODROWGUY.COM

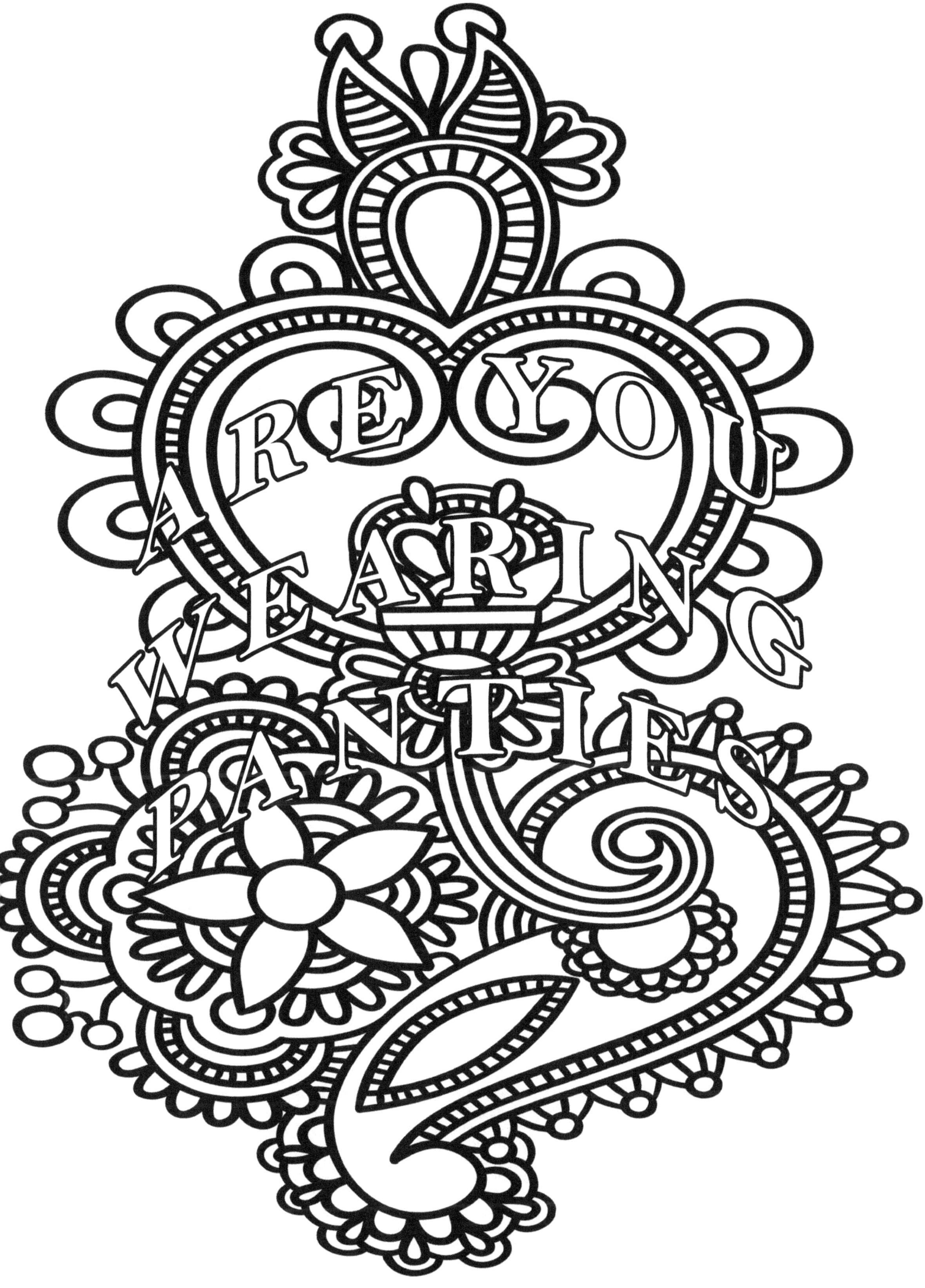

This is a Bleed Through Page If You Are Using a Coloring Marker or Pen!
Find Other Great Titles By Us. Search on Your Favorite Book Retailer
Just search for the author name of Woodrow Guy .
He also Publishes Lite Erotica on Amazon Kindle
CHECK OUT OUR WEBSITE FOR ALL OUR ADULT CREATIONS
WWW.WOODROWGUY.COM

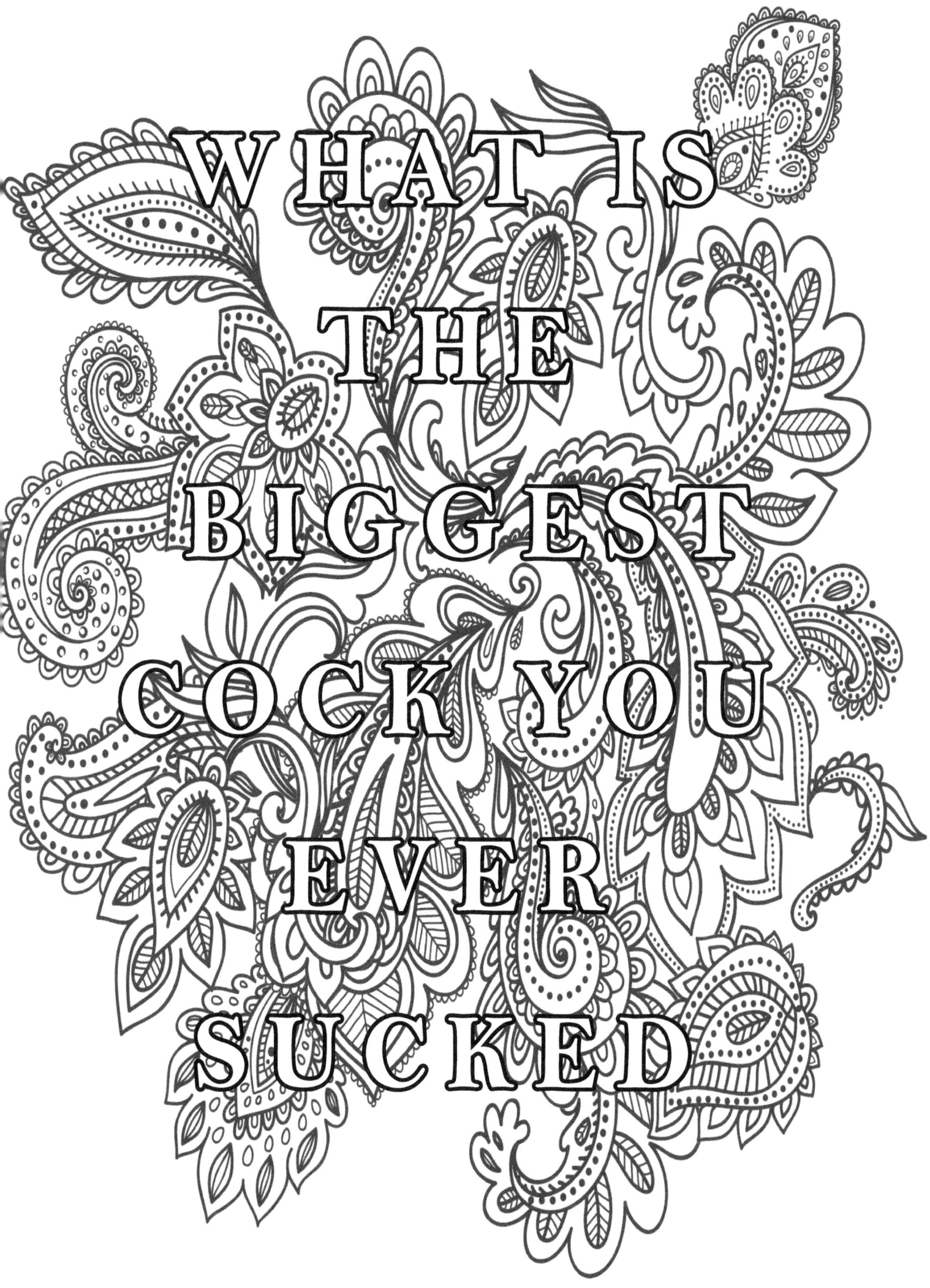

This is a Bleed Through Page If You Are Using a Coloring Marker or Pen!
Find Other Great Titles By Us. Search on Your Favorite Book Retailer
Just search for the author name of Woodrow Guy .
He also Publishes Lite Erotica on Amazon Kindle
**CHECK OUT OUR WEBSITE FOR ALL OUR ADULT CREATIONS
WWW.WOODROWGUY.COM**

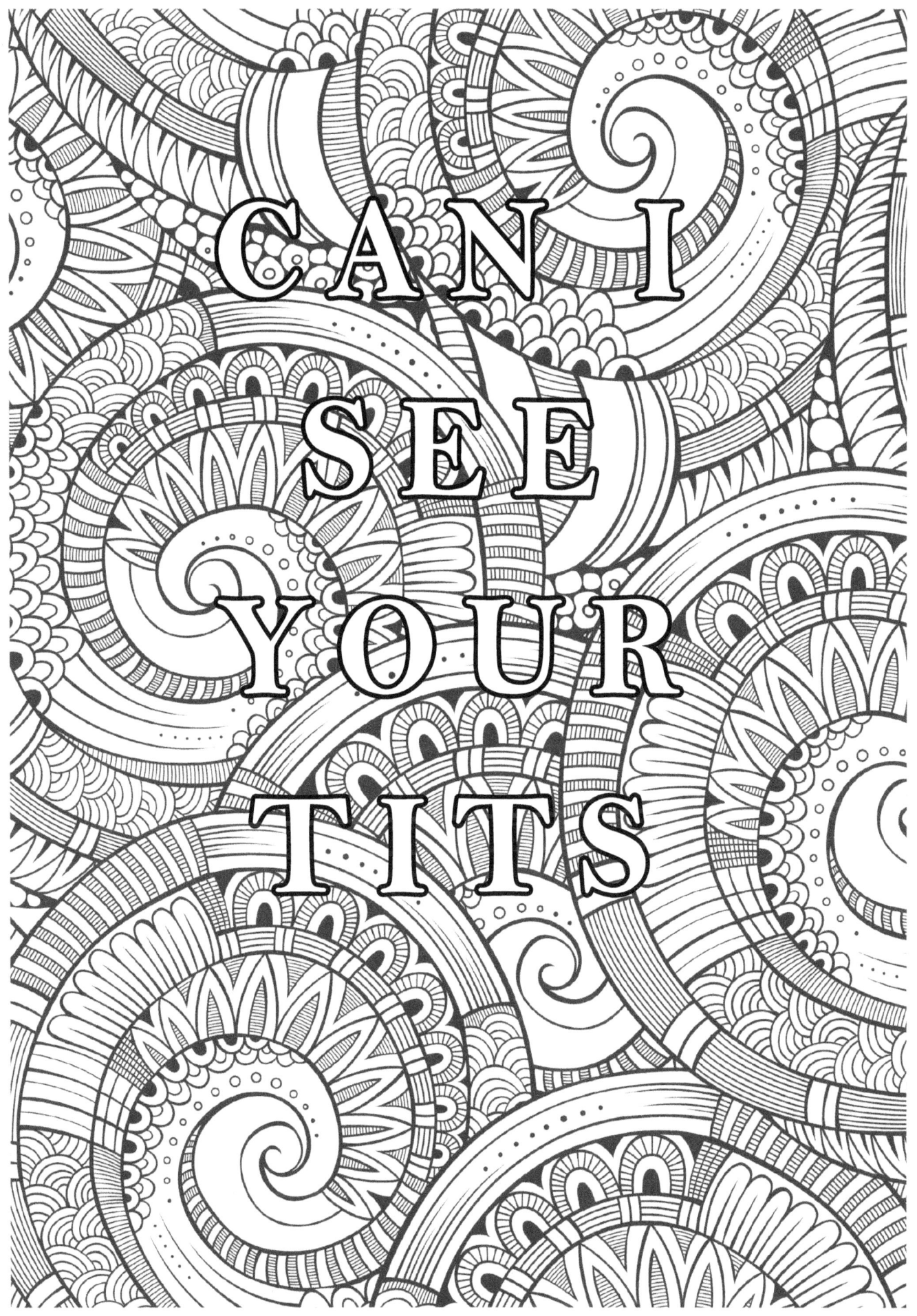

This is a Bleed Through Page If You Are Using a Coloring Marker or Pen!
Find Other Great Titles By Us. Search on Your Favorite Book Retailer
Just search for the author name of Woodrow Guy .
He also Publishes Lite Erotica on Amazon Kindle
CHECK OUT OUR WEBSITE FOR ALL OUR ADULT CREATIONS
WWW.WOODROWGUY.COM

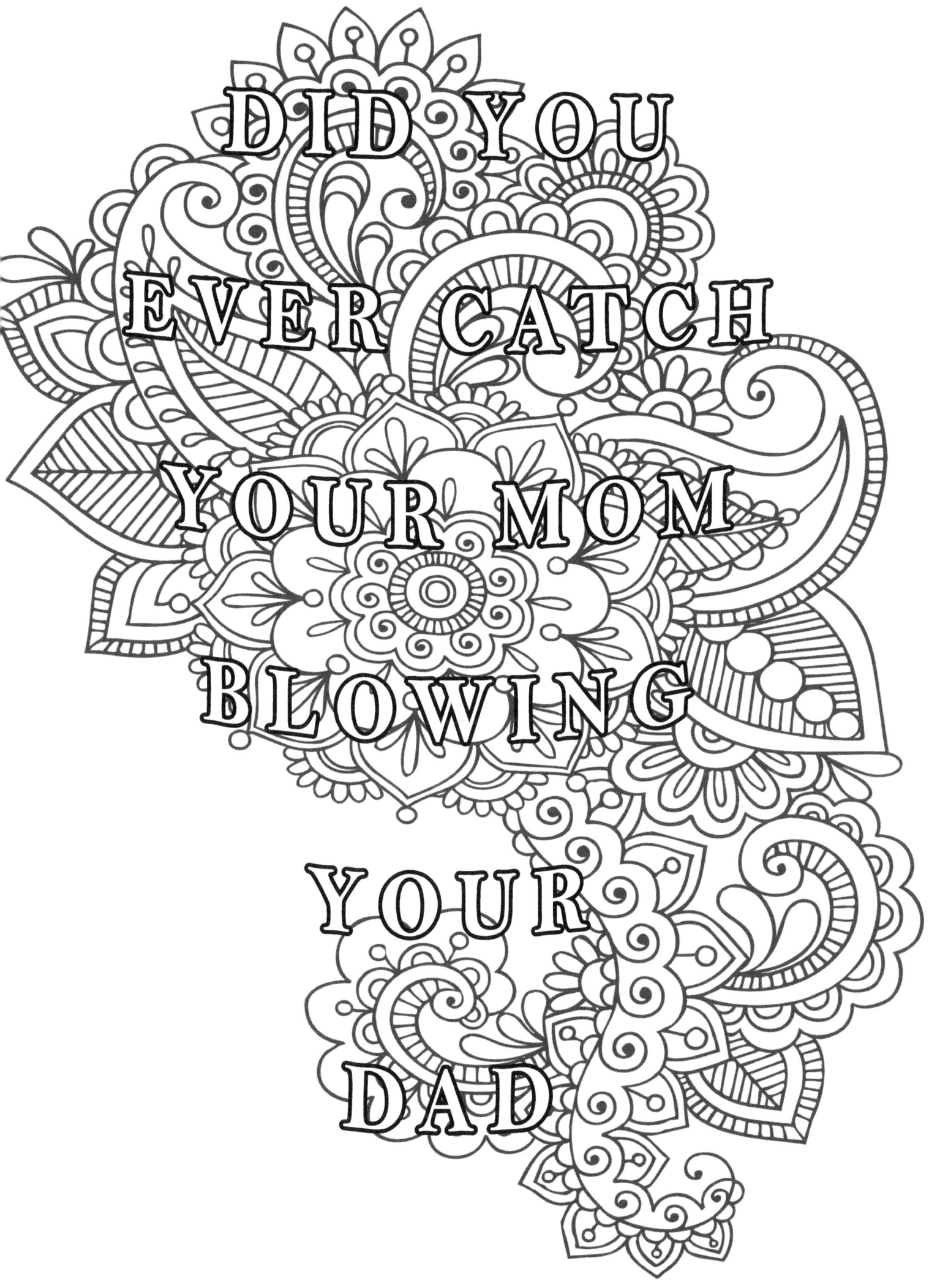

This is a Bleed Through Page If You Are Using a Coloring Marker or Pen!
Find Other Great Titles By Us. Search on Your Favorite Book Retailer
**Just search for the author name of Woodrow Guy .
He also Publishes Lite Erotica on Amazon Kindle
CHECK OUT OUR WEBSITE FOR ALL OUR ADULT CREATIONS
WWW.WOODROWGUY.COM**

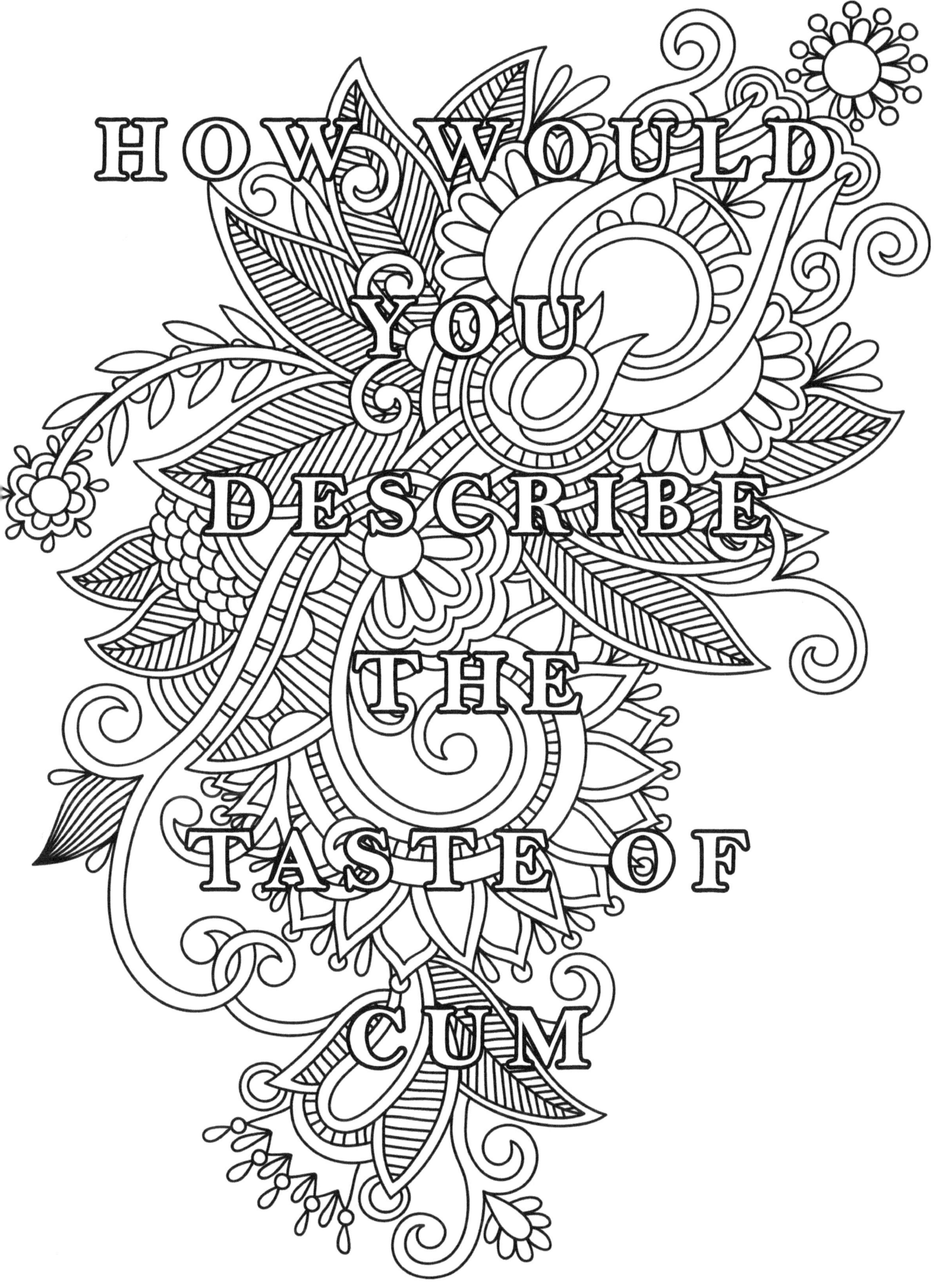

This is a Bleed Through Page If You Are Using a Coloring Marker or Pen!
Find Other Great Titles By Us. Search on Your Favorite Book Retailer
**Just search for the author name of Woodrow Guy .
He also Publishes Lite Erotica on Amazon Kindle
CHECK OUT OUR WEBSITE FOR ALL OUR ADULT CREATIONS
WWW.WOODROWGUY.COM**

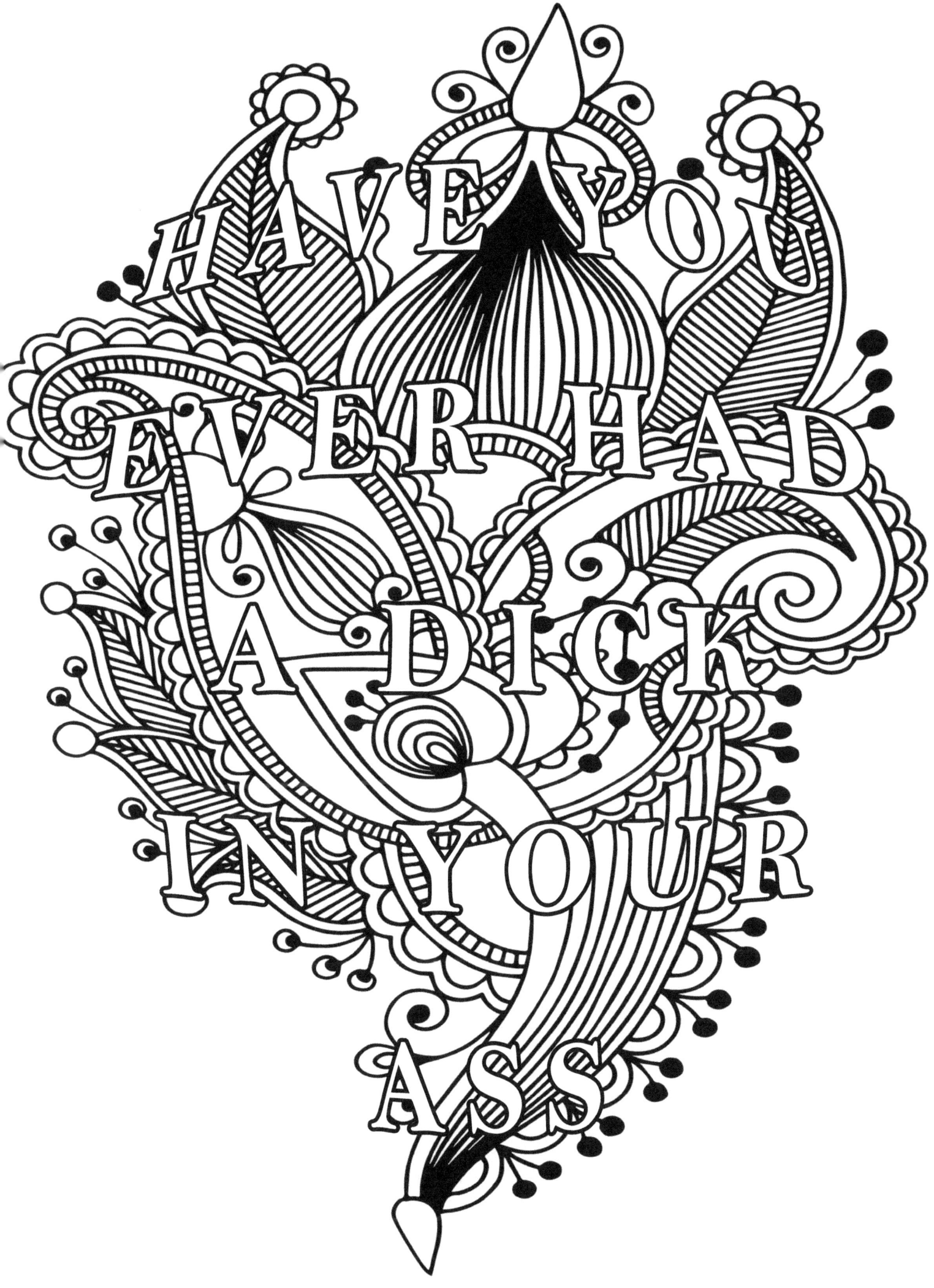

This is a Bleed Through Page If You Are Using a Coloring Marker or Pen!
Find Other Great Titles By Us. Search on Your Favorite Book Retailer
**Just search for the author name of Woodrow Guy .
He also Publishes Lite Erotica on Amazon Kindle
CHECK OUT OUR WEBSITE FOR ALL OUR ADULT CREATIONS
WWW.WOODROWGUY.COM**

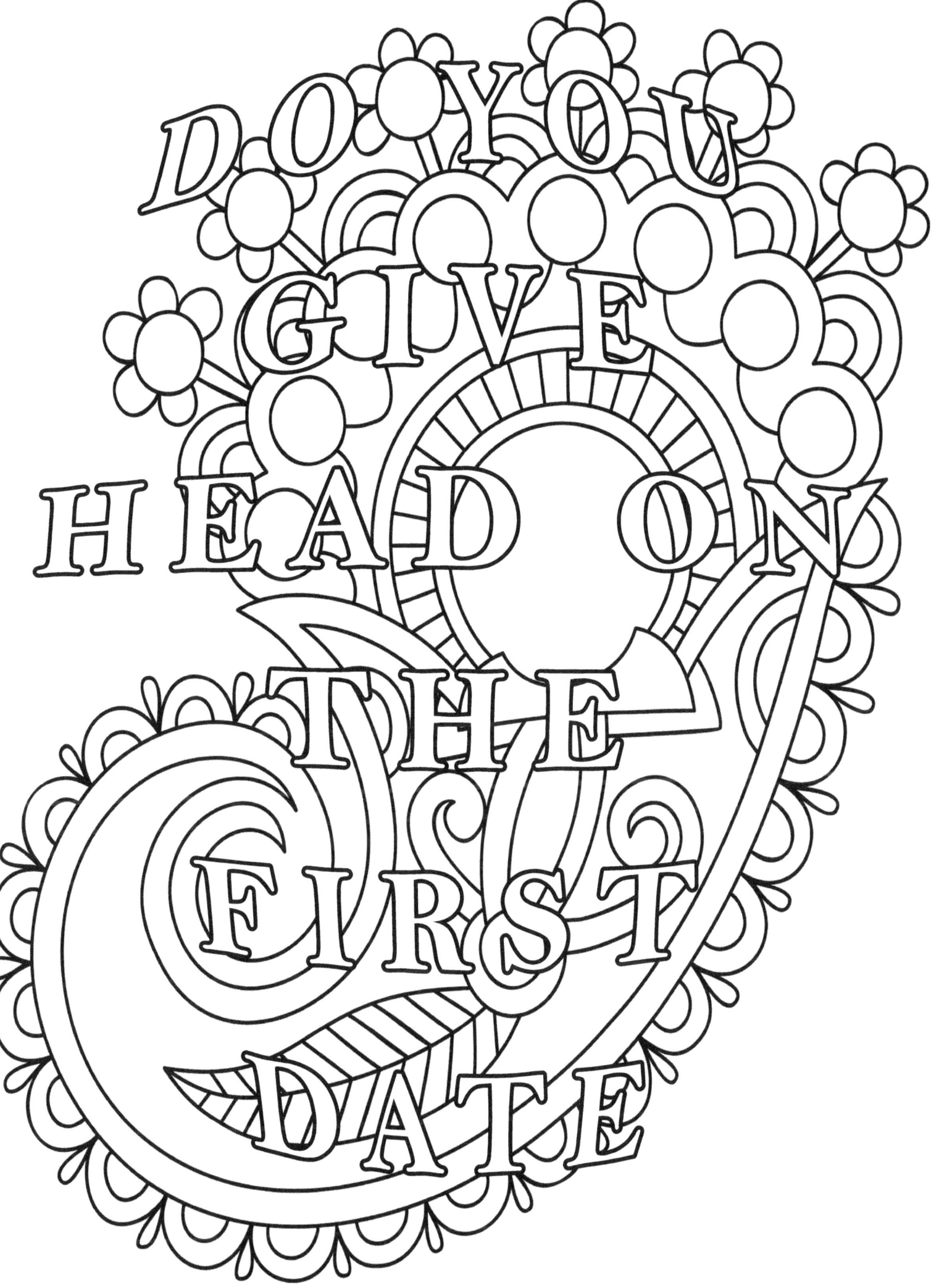

This is a Bleed Through Page If You Are Using a Coloring Marker or Pen!
Find Other Great Titles By Us. Search on Your Favorite Book Retailer
Just search for the author name of Woodrow Guy .
He also Publishes Lite Erotica on Amazon Kindle
**CHECK OUT OUR WEBSITE FOR ALL OUR ADULT CREATIONS
WWW.WOODROWGUY.COM**

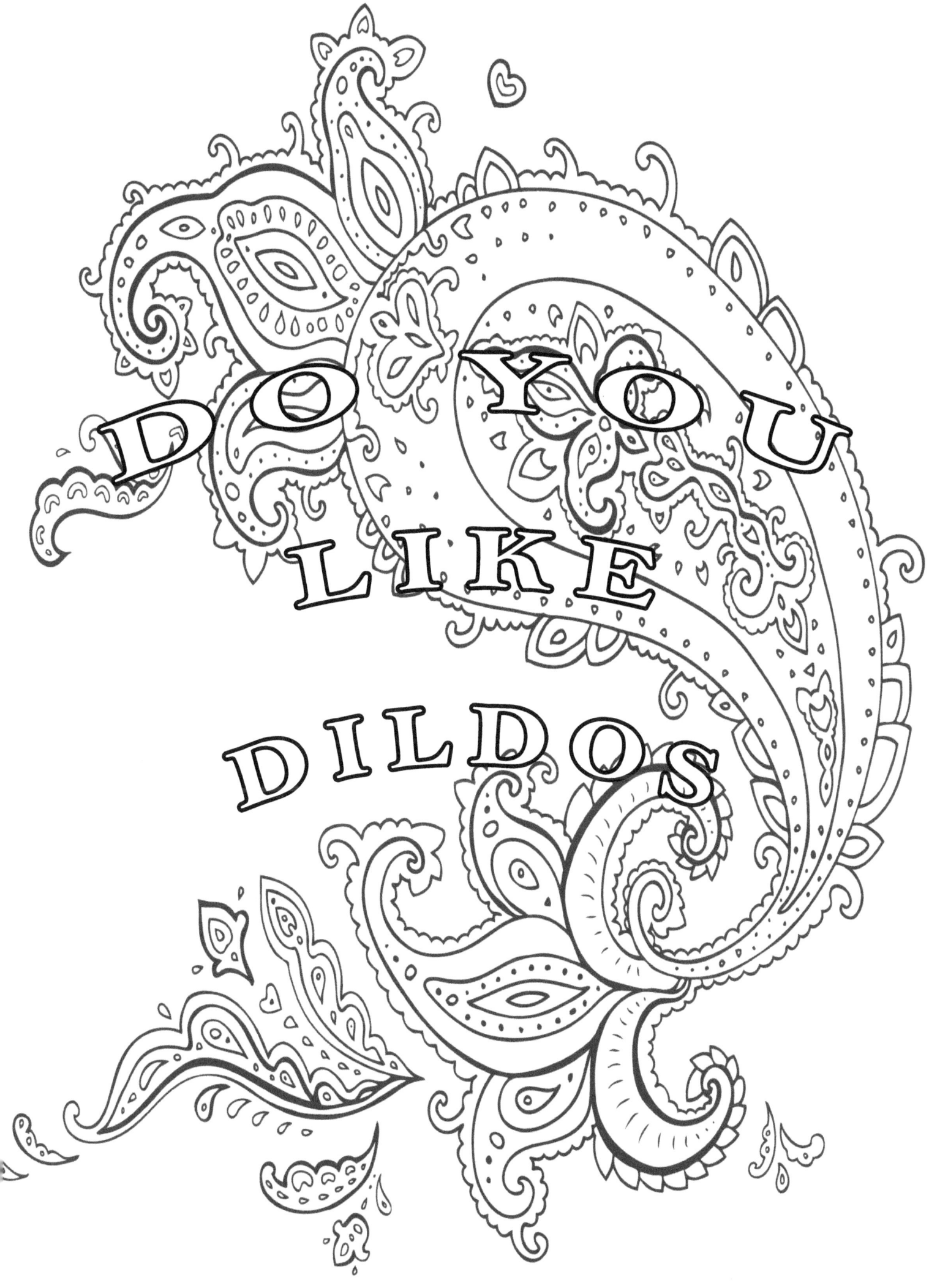

This is a Bleed Through Page If You Are Using a Coloring Marker or Pen!
Find Other Great Titles By Us. Search on Your Favorite Book Retailer
Just search for the author name of Woodrow Guy .
He also Publishes Lite Erotica on Amazon Kindle
CHECK OUT OUR WEBSITE FOR ALL OUR ADULT CREATIONS
WWW.WOODROWGUY.COM

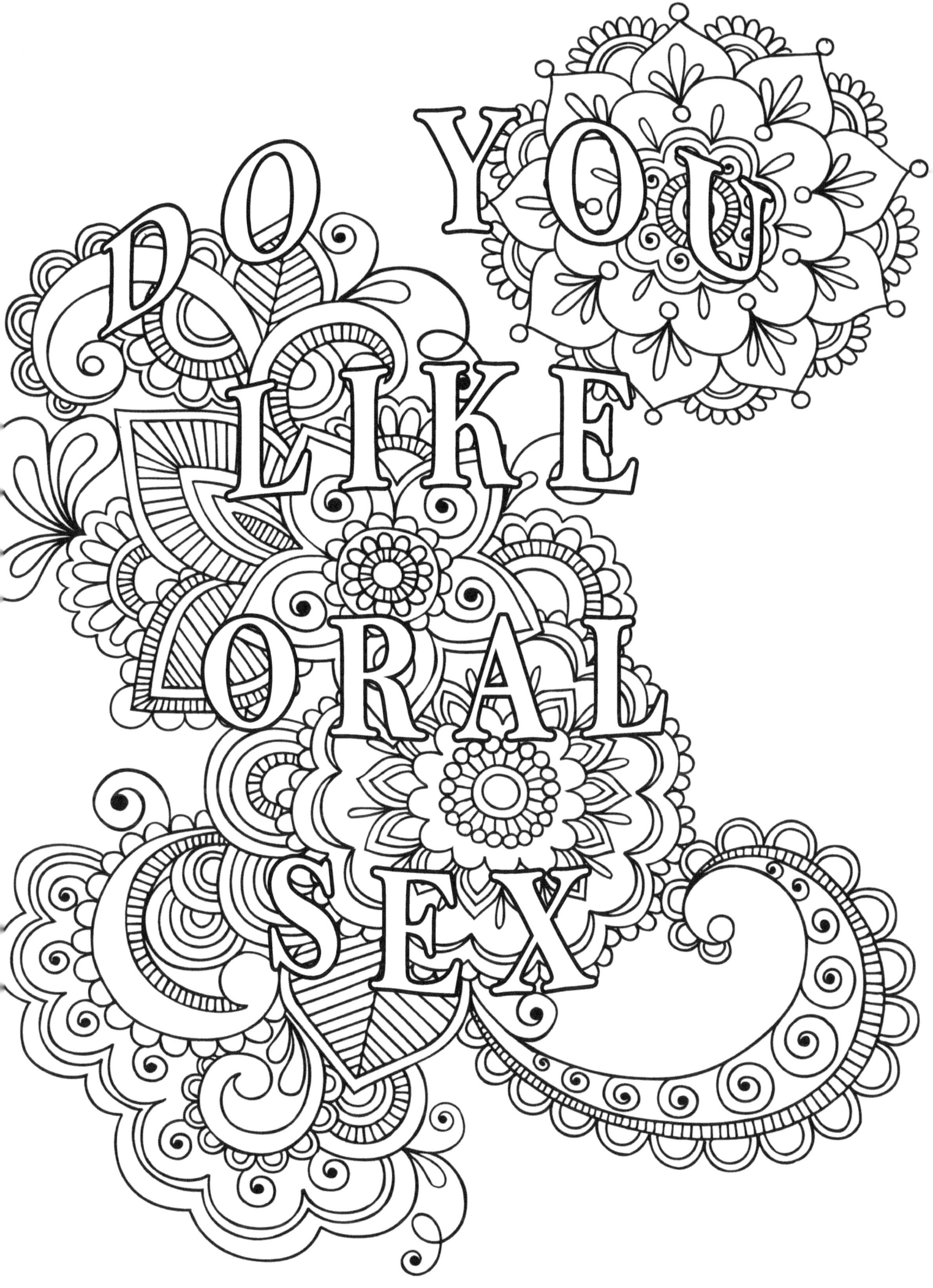

This is a Bleed Through Page If You Are Using a Coloring Marker or Pen!
Find Other Great Titles By Us. Search on Your Favorite Book Retailer
**Just search for the author name of Woodrow Guy .
He also Publishes Lite Erotica on Amazon Kindle
CHECK OUT OUR WEBSITE FOR ALL OUR ADULT CREATIONS
WWW.WOODROWGUY.COM**

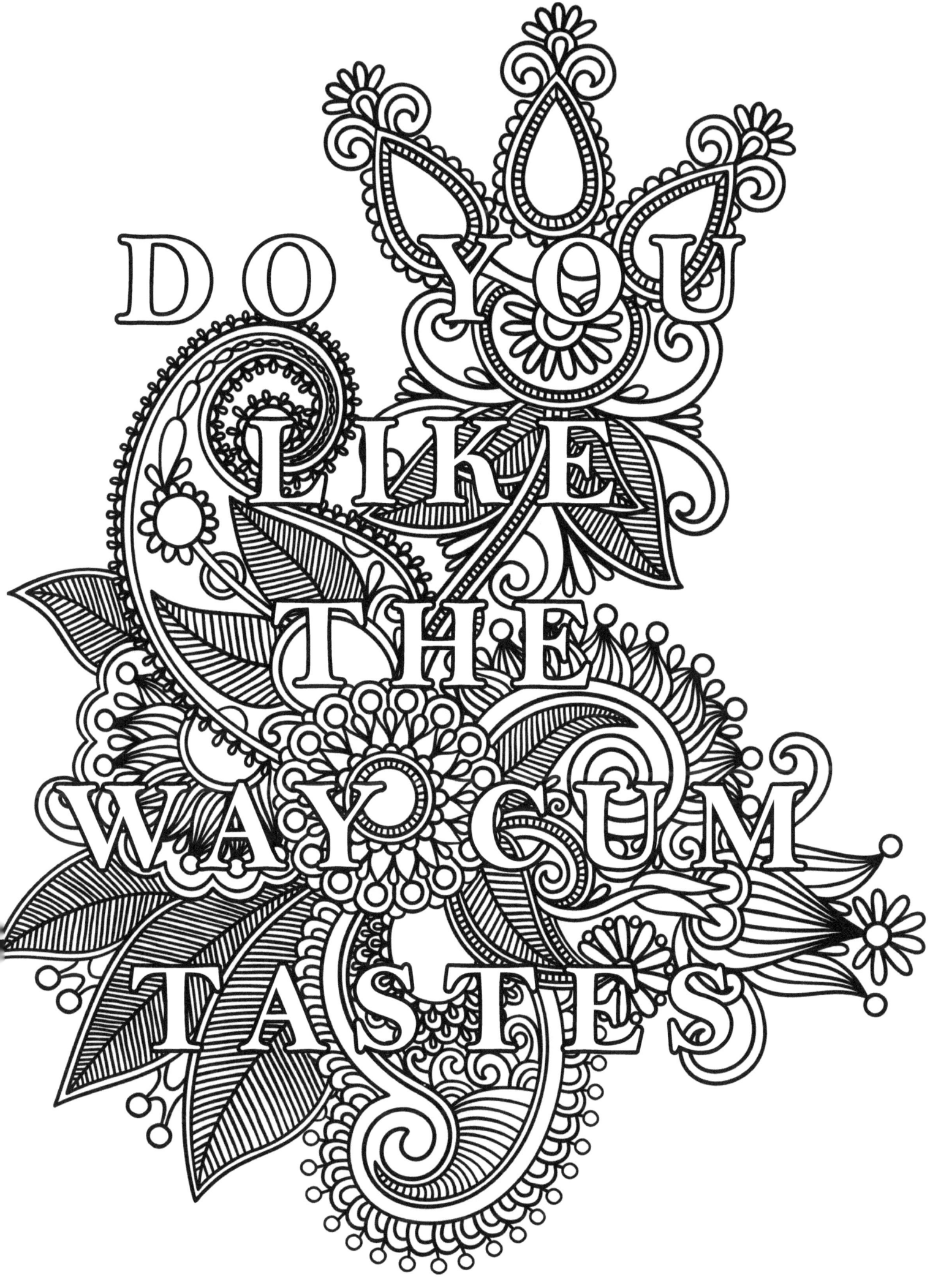

This is a Bleed Through Page If You Are Using a Coloring Marker or Pen!
Find Other Great Titles By Us. Search on Your Favorite Book Retailer
**Just search for the author name of Woodrow Guy .
He also Publishes Lite Erotica on Amazon Kindle
CHECK OUT OUR WEBSITE FOR ALL OUR ADULT CREATIONS
WWW.WOODROWGUY.COM**

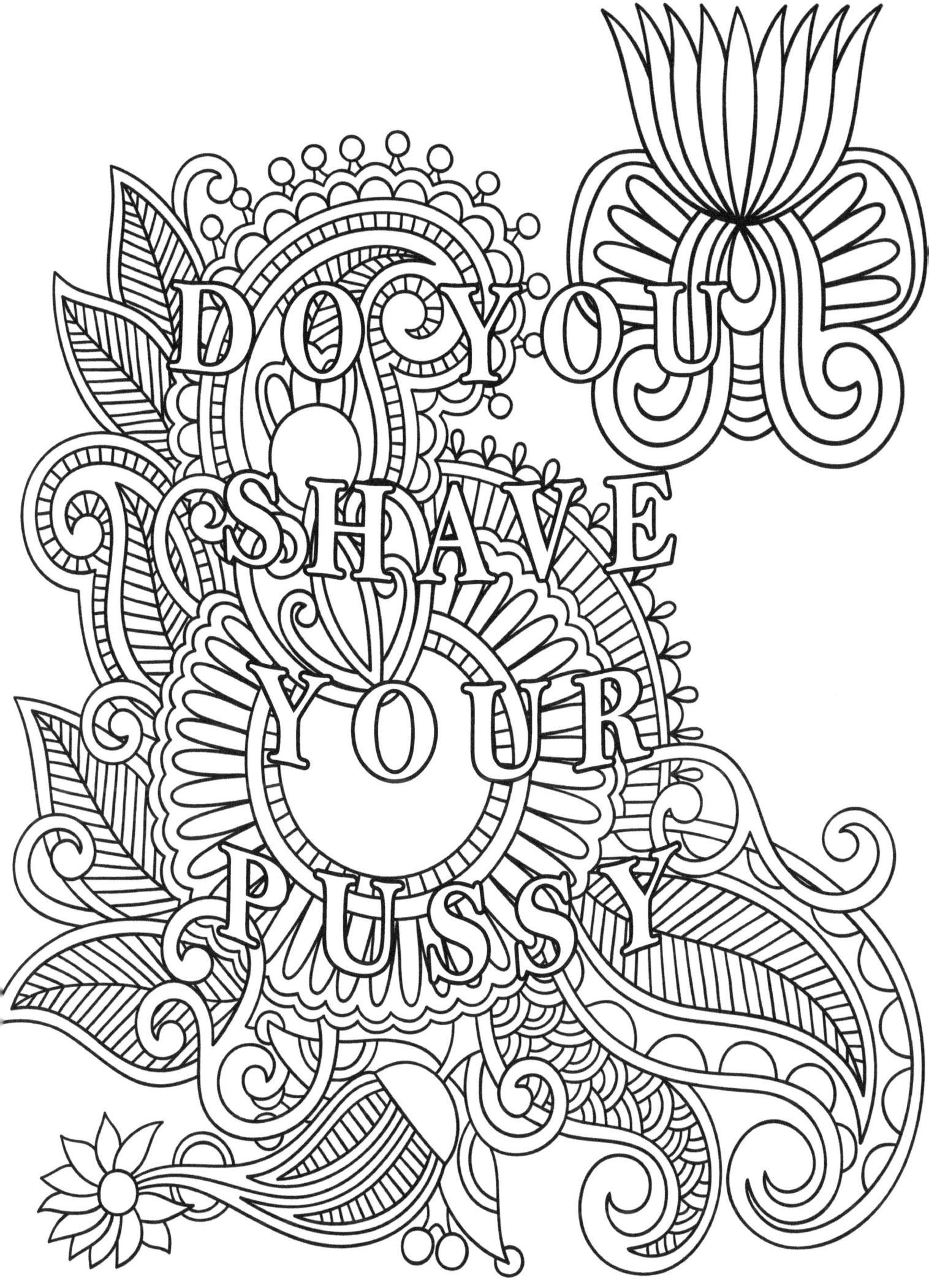

This is a Bleed Through Page If You Are Using a Coloring Marker or Pen!
Find Other Great Titles By Us. Search on Your Favorite Book Retailer
Just search for the author name of Woodrow Guy .
He also Publishes Lite Erotica on Amazon Kindle
CHECK OUT OUR WEBSITE FOR ALL OUR ADULT CREATIONS
WWW.WOODROWGUY.COM

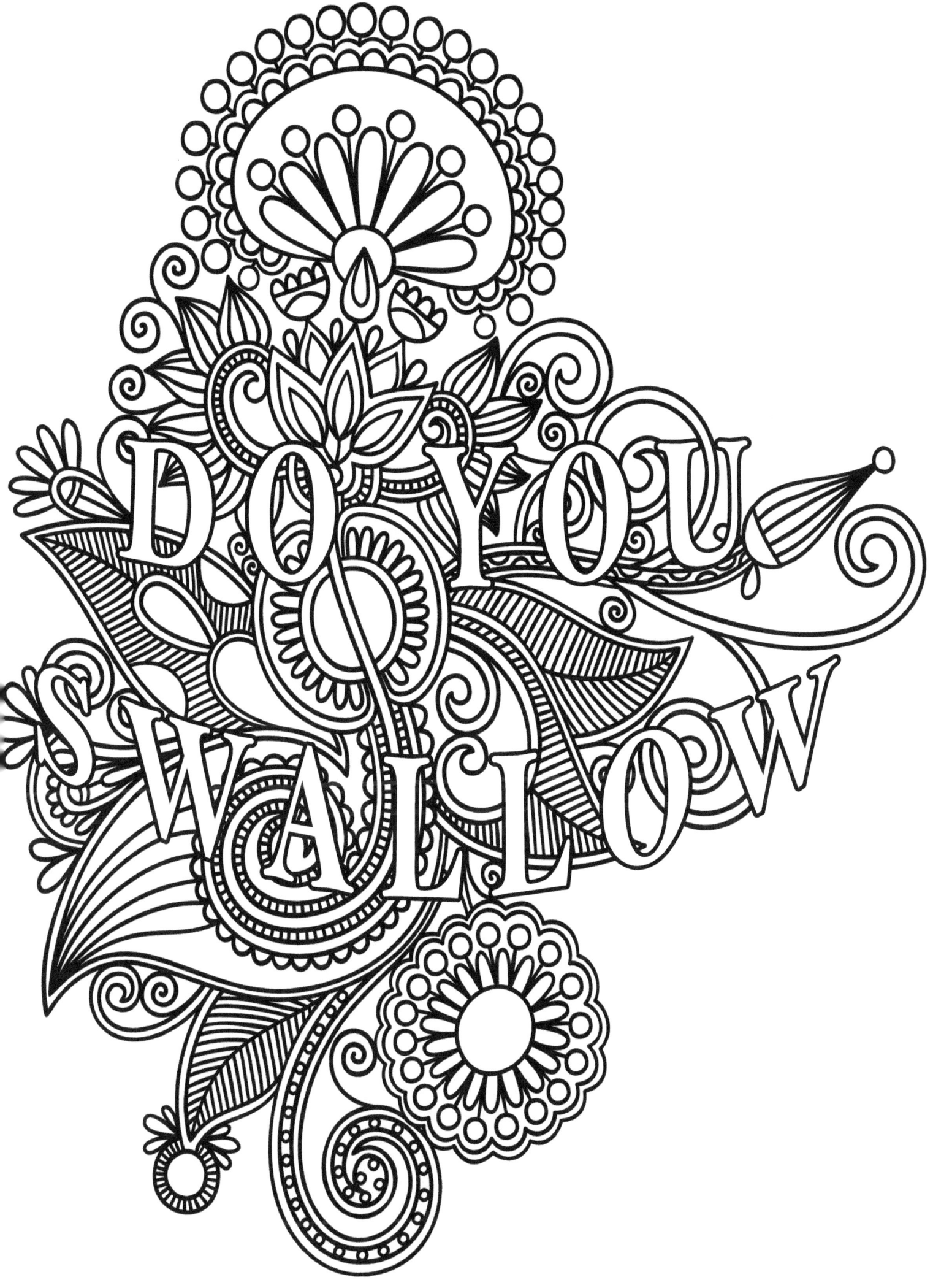

This is a Bleed Through Page If You Are Using a Coloring Marker or Pen!
Find Other Great Titles By Us. Search on Your Favorite Book Retailer
**Just search for the author name of Woodrow Guy .
He also Publishes Lite Erotica on Amazon Kindle
CHECK OUT OUR WEBSITE FOR ALL OUR ADULT CREATIONS
WWW.WOODROWGUY.COM**

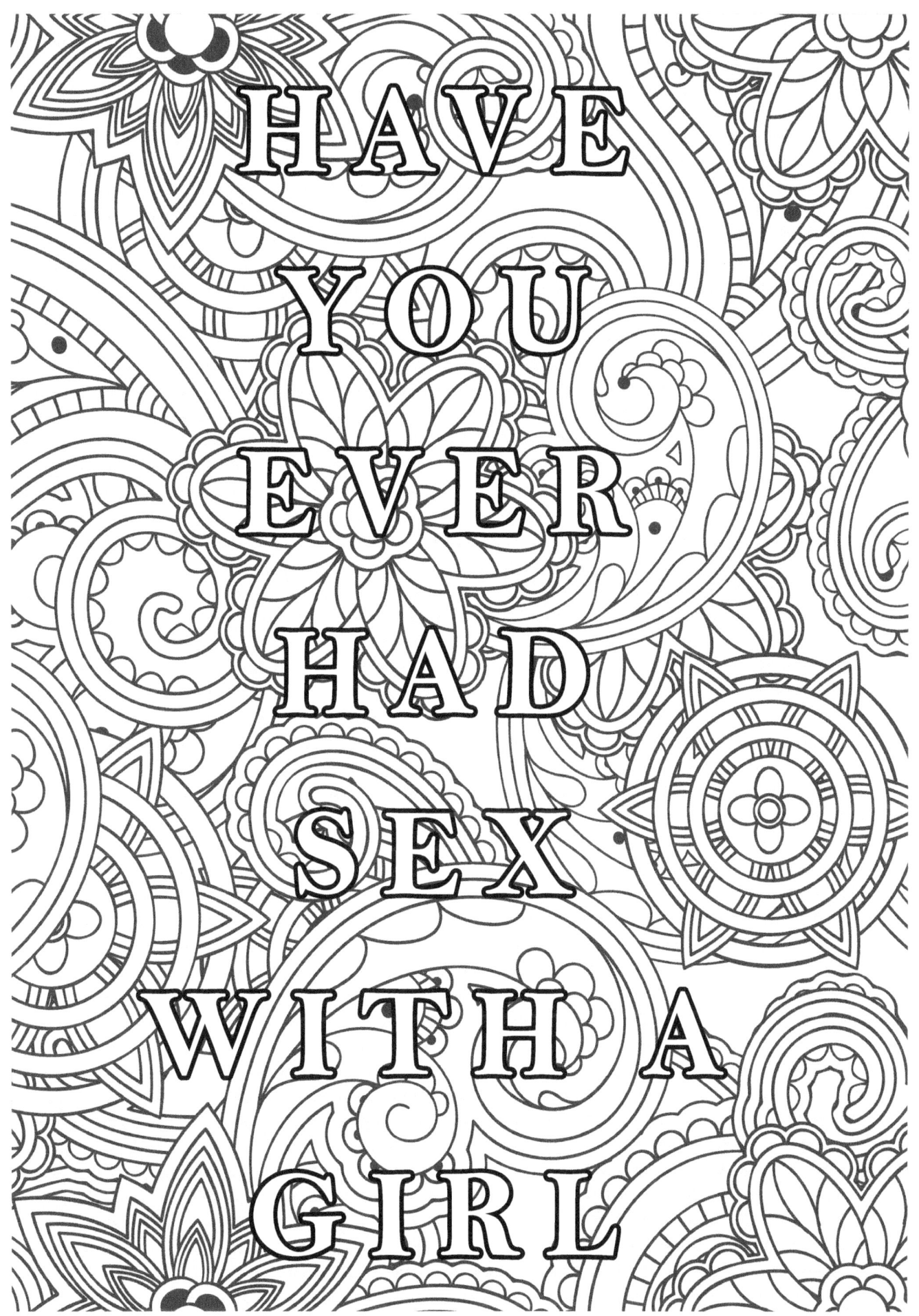

This is a Bleed Through Page If You Are Using a Coloring Marker or Pen!
Find Other Great Titles By Us. Search on Your Favorite Book Retailer
Just search for the author name of Woodrow Guy .
He also Publishes Lite Erotica on Amazon Kindle
**CHECK OUT OUR WEBSITE FOR ALL OUR ADULT CREATIONS
WWW.WOODROWGUY.COM**

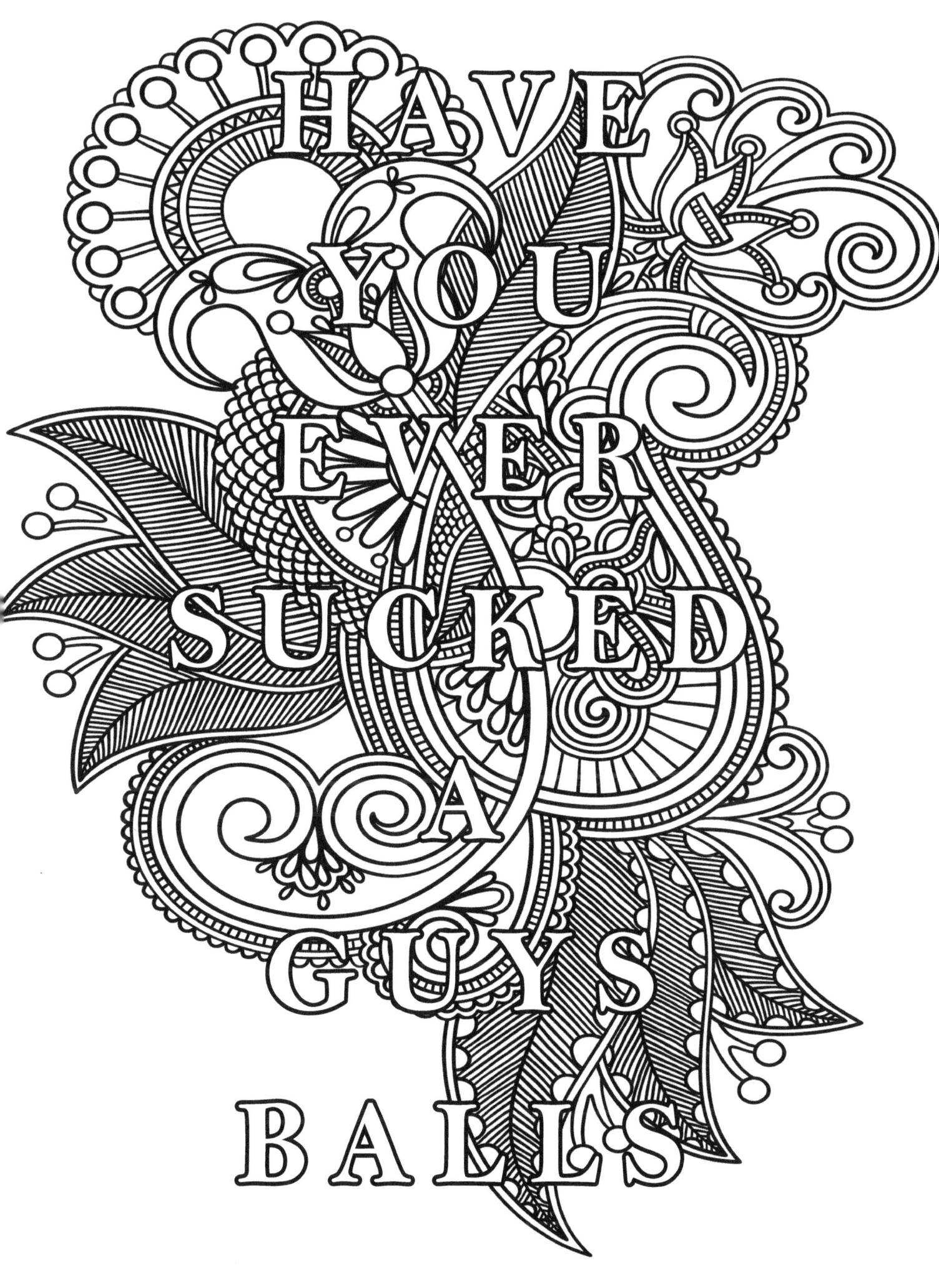

This is a Bleed Through Page If You Are Using a Coloring Marker or Pen!
Find Other Great Titles By Us. Search on Your Favorite Book Retailer
Just search for the author name of Woodrow Guy .
He also Publishes Lite Erotica on Amazon Kindle
CHECK OUT OUR WEBSITE FOR ALL OUR ADULT CREATIONS
WWW.WOODROWGUY.COM

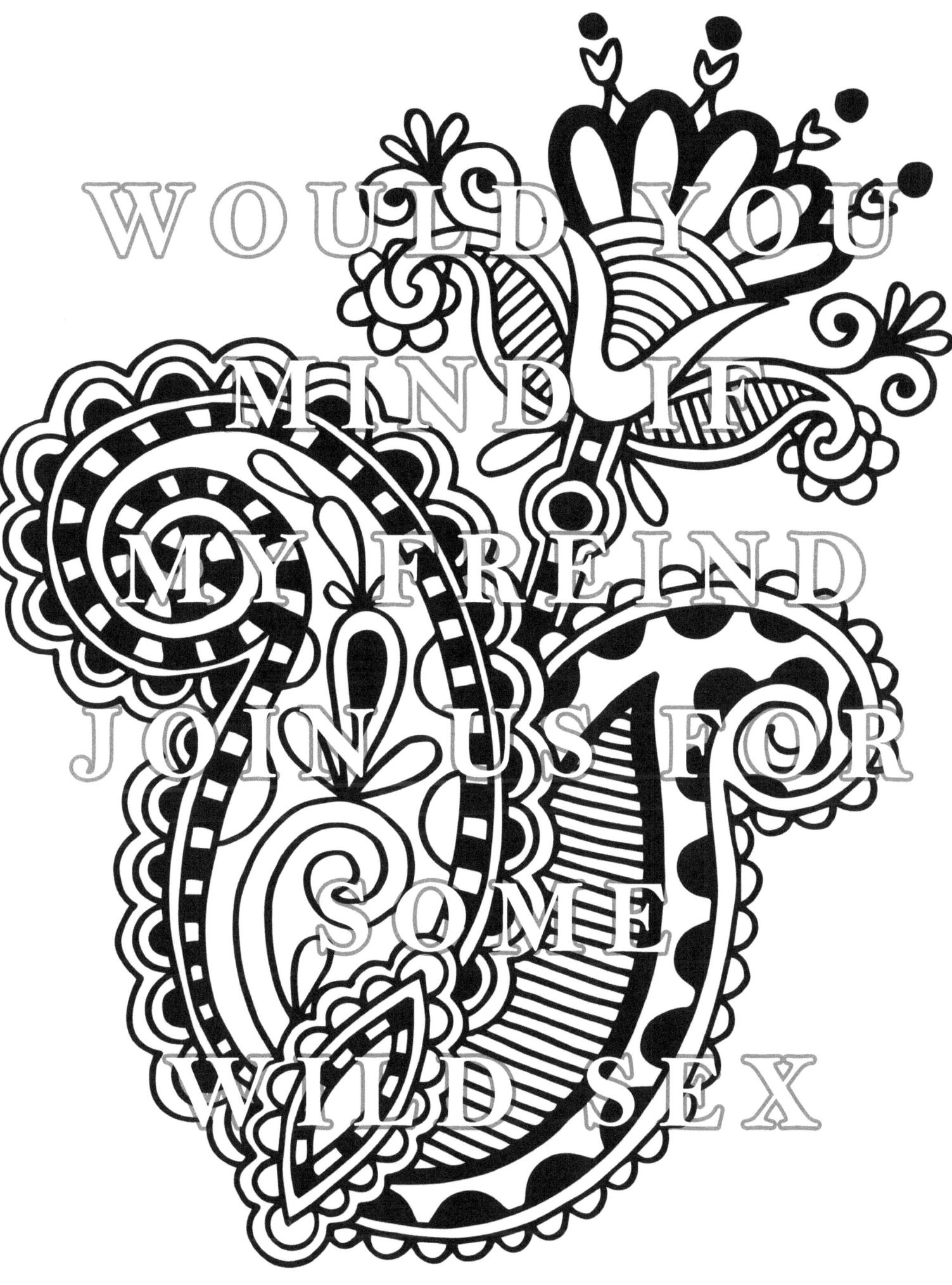

This is a Bleed Through Page If You Are Using a Coloring Marker or Pen!
Find Other Great Titles By Us. Search on Your Favorite Book Retailer
Just search for the author name of Woodrow Guy .
He also Publishes Lite Erotica on Amazon Kindle
CHECK OUT OUR WEBSITE FOR ALL OUR ADULT CREATIONS
WWW.WOODROWGUY.COM

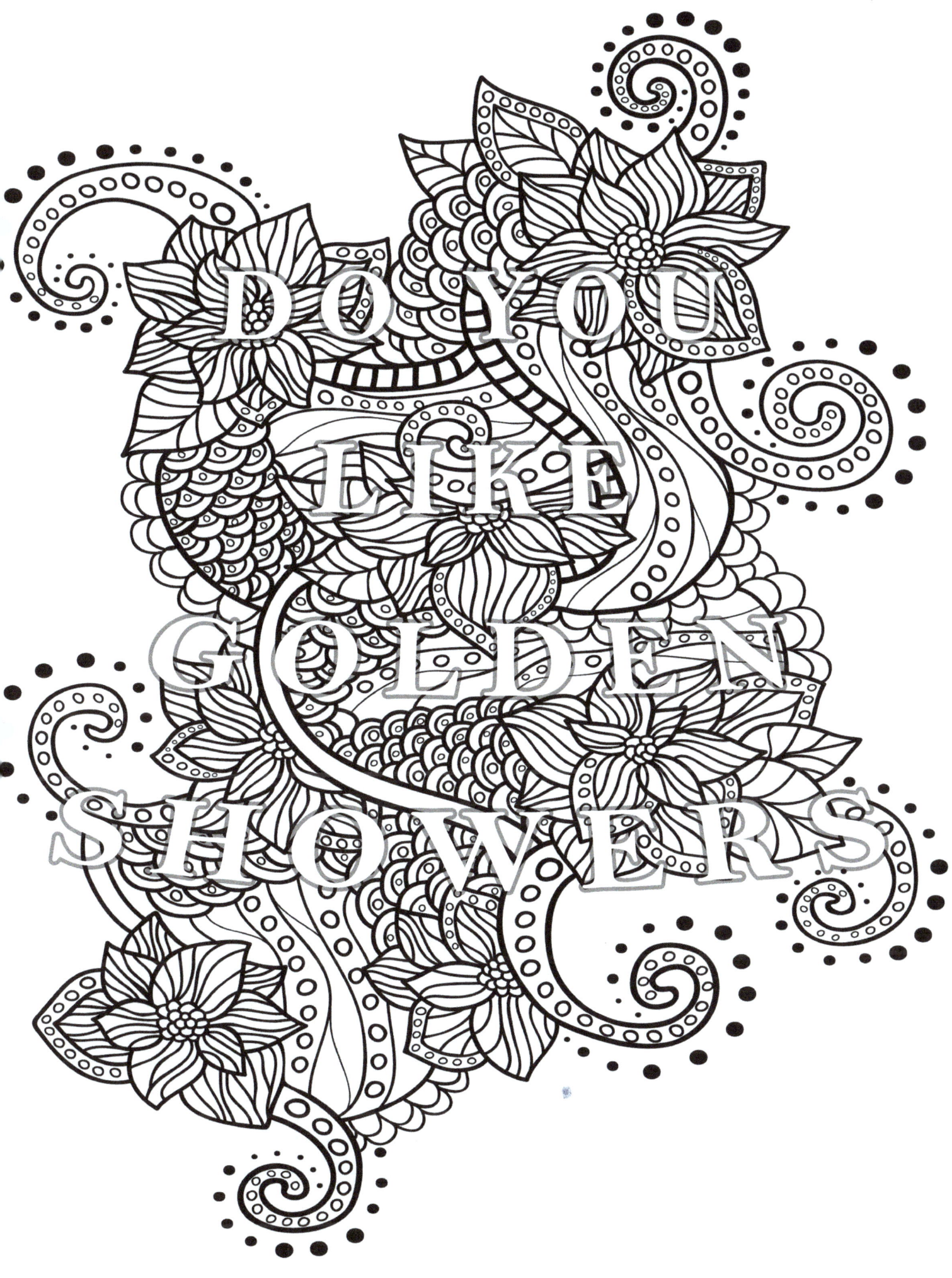

This is a Bleed Through Page If You Are Using a Coloring Marker or Pen!
Find Other Great Titles By Us. Search on Your Favorite Book Retailer
Just search for the author name of Woodrow Guy .
He also Publishes Lite Erotica on Amazon Kindle
CHECK OUT OUR WEBSITE FOR ALL OUR ADULT CREATIONS
WWW.WOODROWGUY.COM

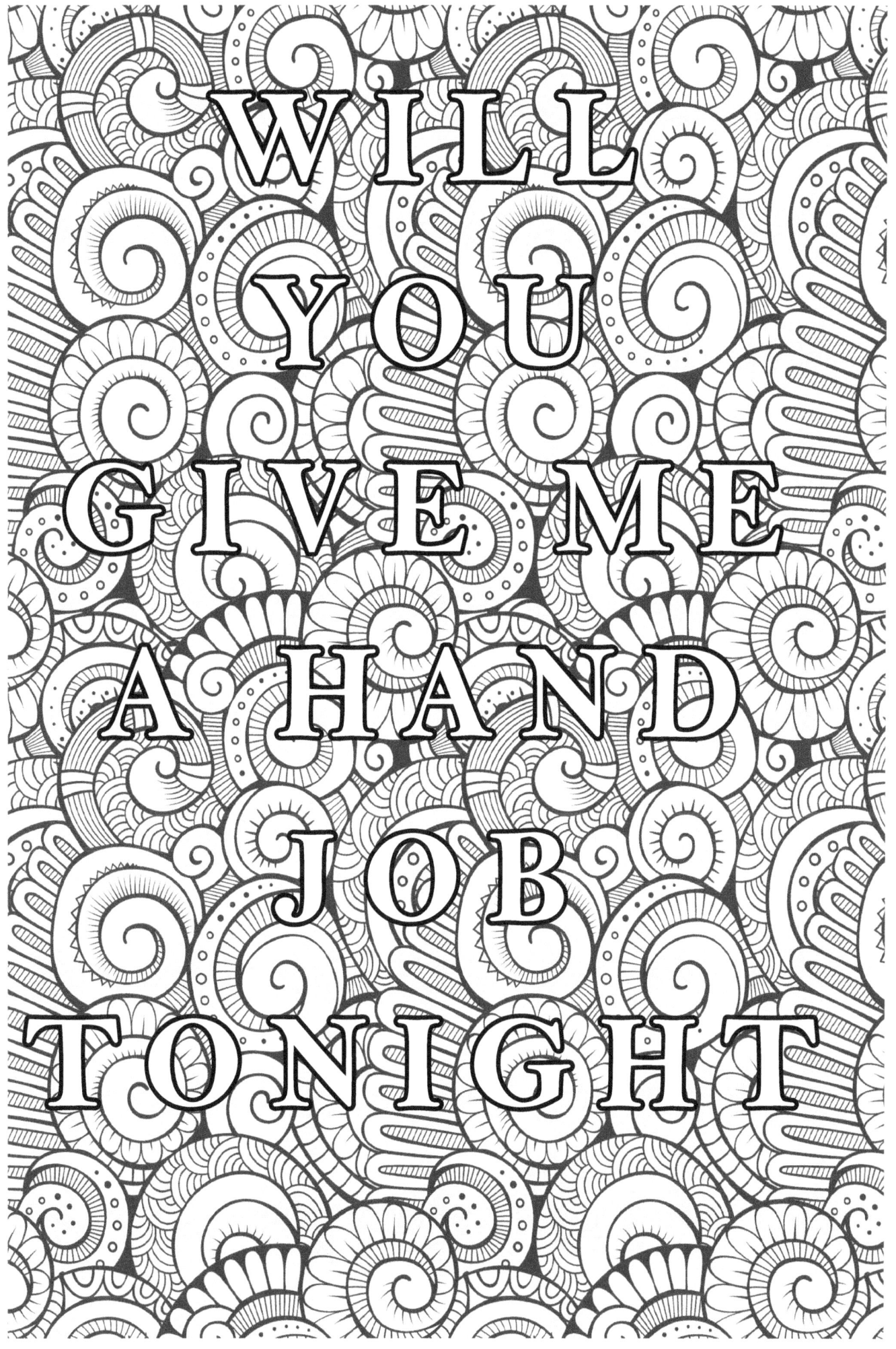

This is a Bleed Through Page If You Are Using a Coloring Marker or Pen!
Find Other Great Titles By Us. Search on Your Favorite Book Retailer
Just search for the author name of Woodrow Guy .
He also Publishes Lite Erotica on Amazon Kindle
CHECK OUT OUR WEBSITE FOR ALL OUR ADULT CREATIONS
WWW.WOODROWGUY.COM

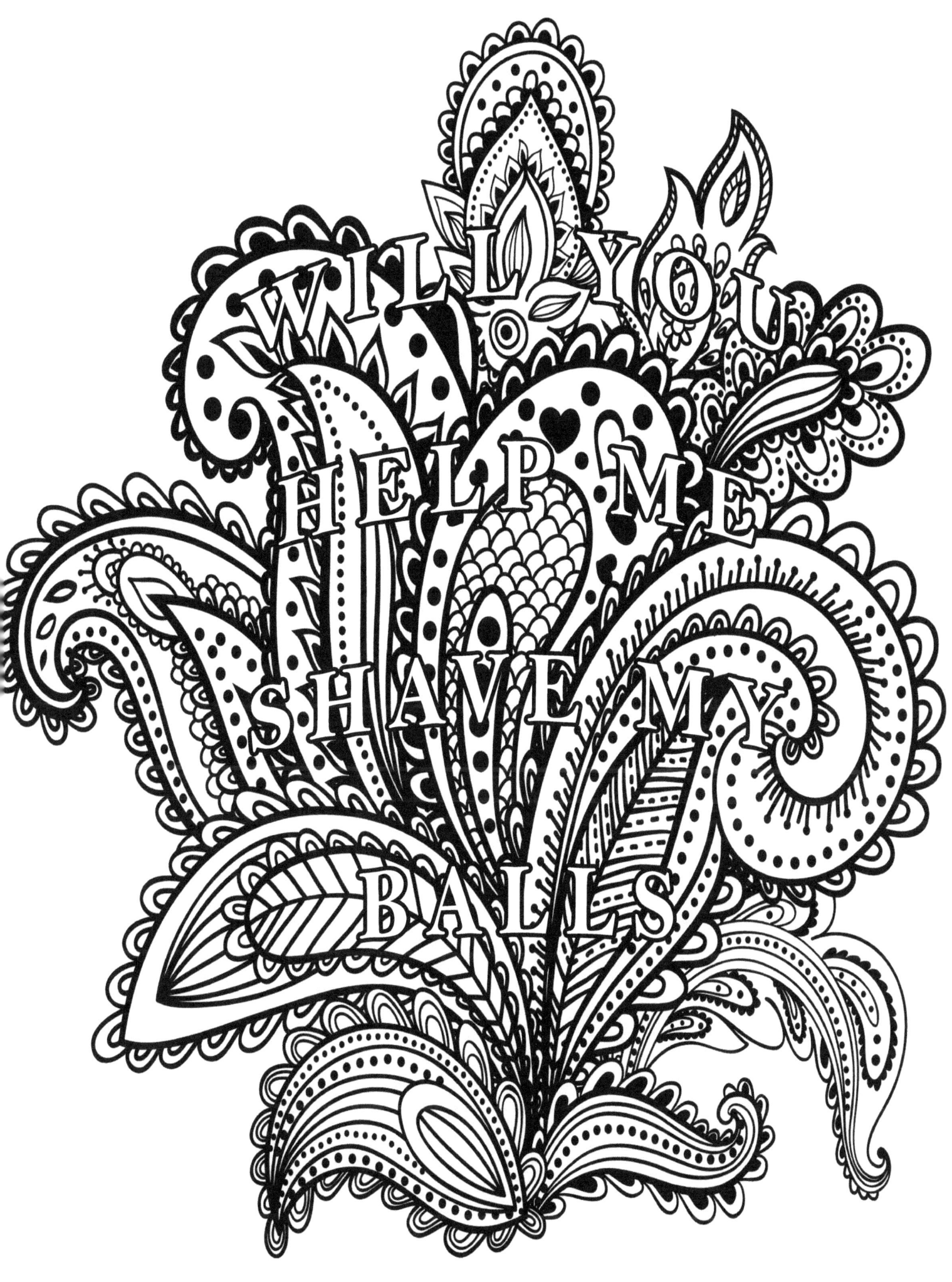

This is a Bleed Through Page If You Are Using a Coloring Marker or Pen!
Find Other Great Titles By Us. Search on Your Favorite Book Retailer
Just search for the author name of Woodrow Guy .
He also Publishes Lite Erotica on Amazon Kindle
**CHECK OUT OUR WEBSITE FOR ALL OUR ADULT CREATIONS
WWW.WOODROWGUY.COM**

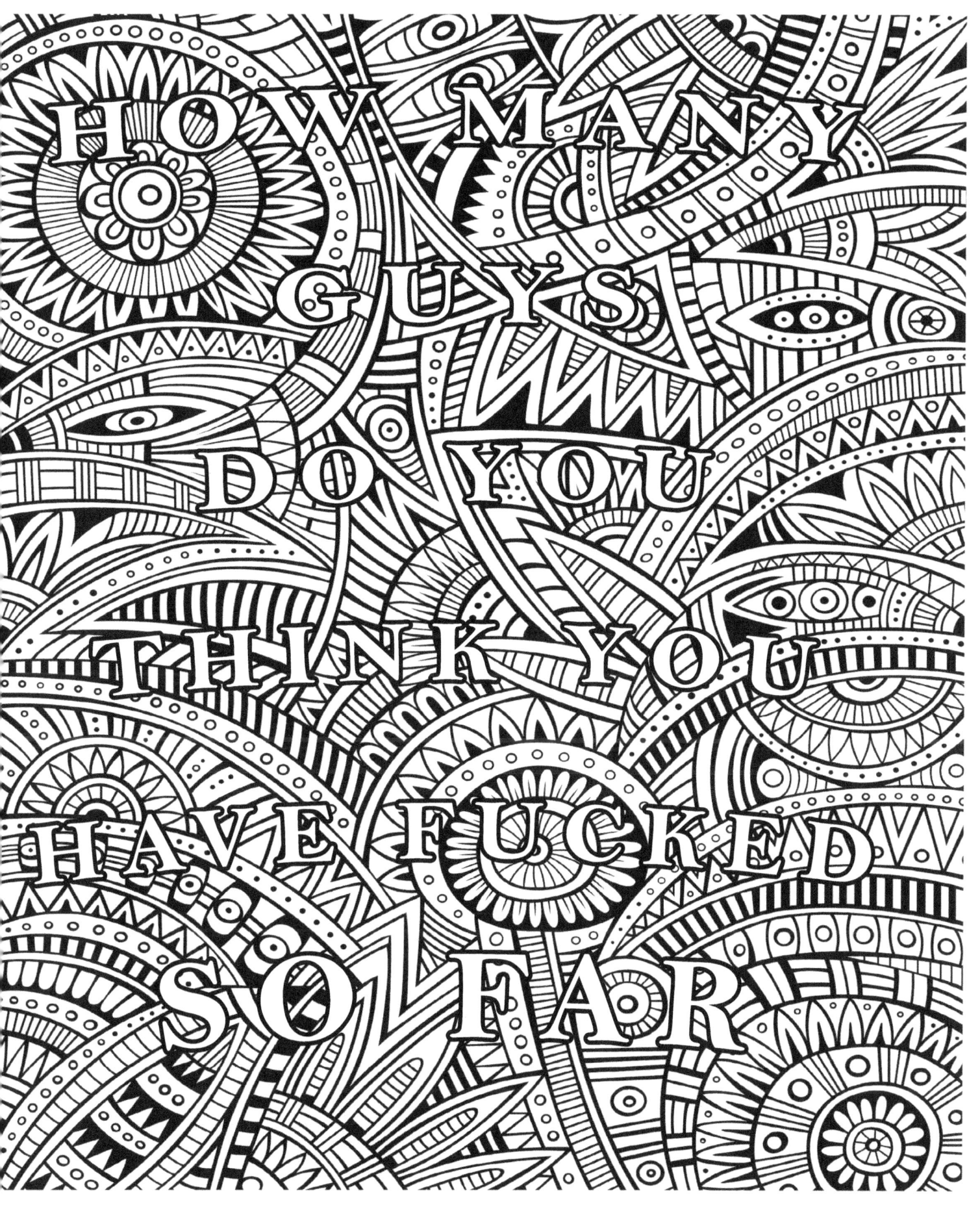

This is a Bleed Through Page If You Are Using a Coloring Marker or Pen!
Find Other Great Titles By Us. Search on Your Favorite Book Retailer
**Just search for the author name of Woodrow Guy .
He also Publishes Lite Erotica on Amazon Kindle
CHECK OUT OUR WEBSITE FOR ALL OUR ADULT CREATIONS
WWW.WOODROWGUY.COM**

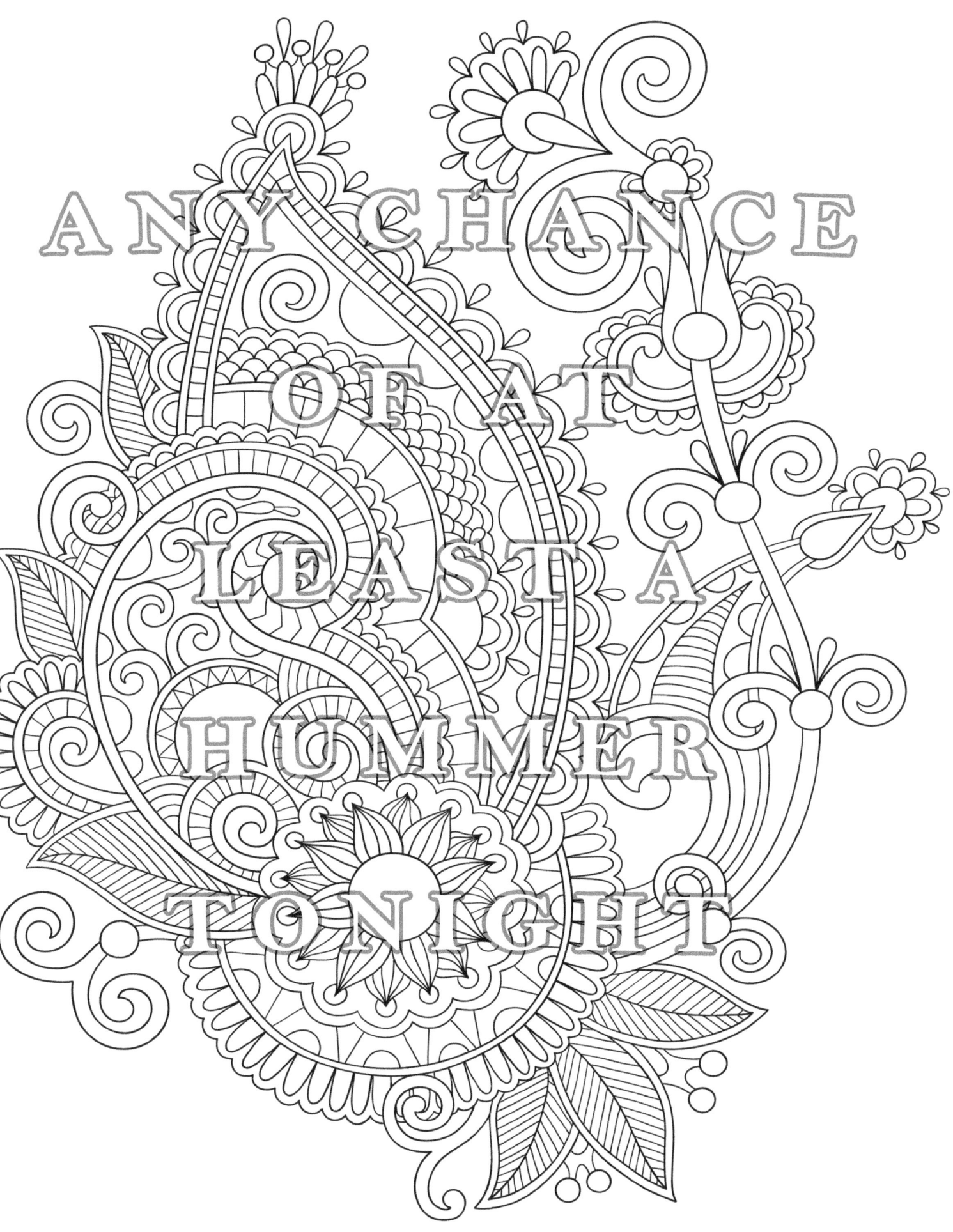

This is a Bleed Through Page If You Are Using a Coloring Marker or Pen!
Find Other Great Titles By Us. Search on Your Favorite Book Retailer
**Just search for the author name of Woodrow Guy .
He also Publishes Lite Erotica on Amazon Kindle
CHECK OUT OUR WEBSITE FOR ALL OUR ADULT CREATIONS
WWW.WOODROWGUY.COM**

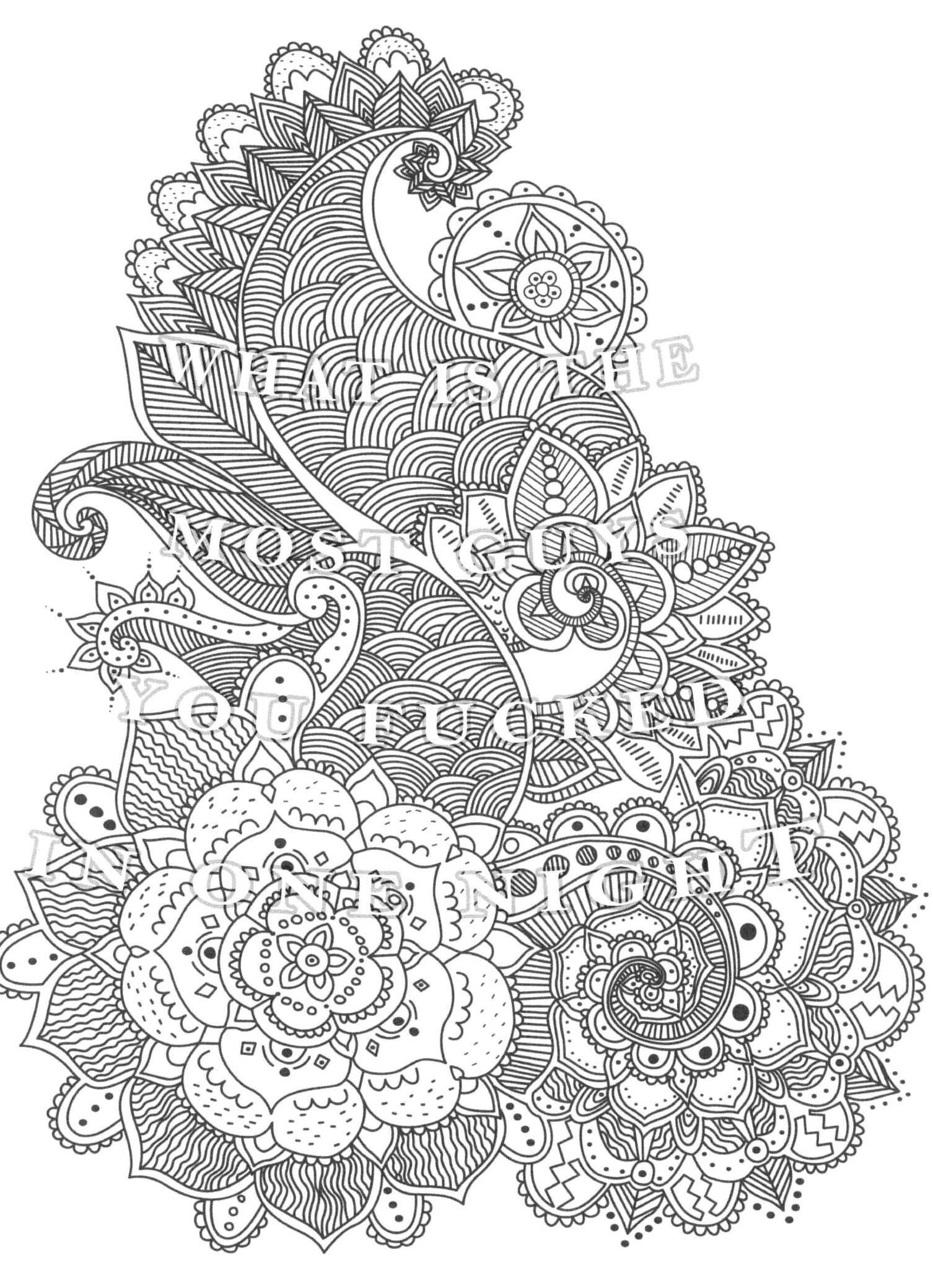

This is a Bleed Through Page If You Are Using a Coloring Marker or Pen!
Find Other Great Titles By Us. Search on Your Favorite Book Retailer
Just search for the author name of Woodrow Guy .
He also Publishes Lite Erotica on Amazon Kindle
CHECK OUT OUR WEBSITE FOR ALL OUR ADULT CREATIONS
WWW.WOODROWGUY.COM

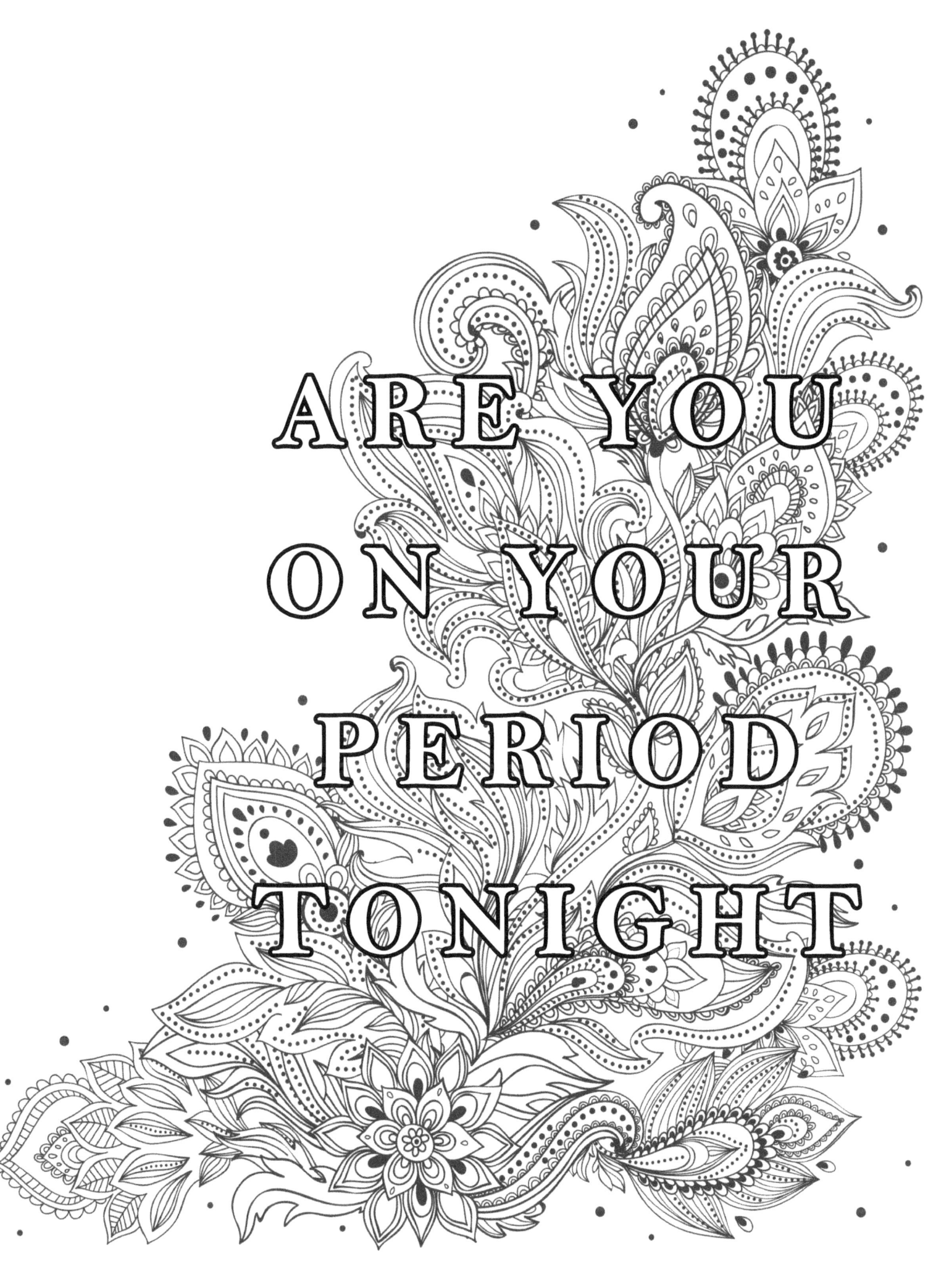

This is a Bleed Through Page If You Are Using a Coloring Marker or Pen!
Find Other Great Titles By Us. Search on Your Favorite Book Retailer
**Just search for the author name of Woodrow Guy .
He also Publishes Lite Erotica on Amazon Kindle
CHECK OUT OUR WEBSITE FOR ALL OUR ADULT CREATIONS
WWW.WOODROWGUY.COM**

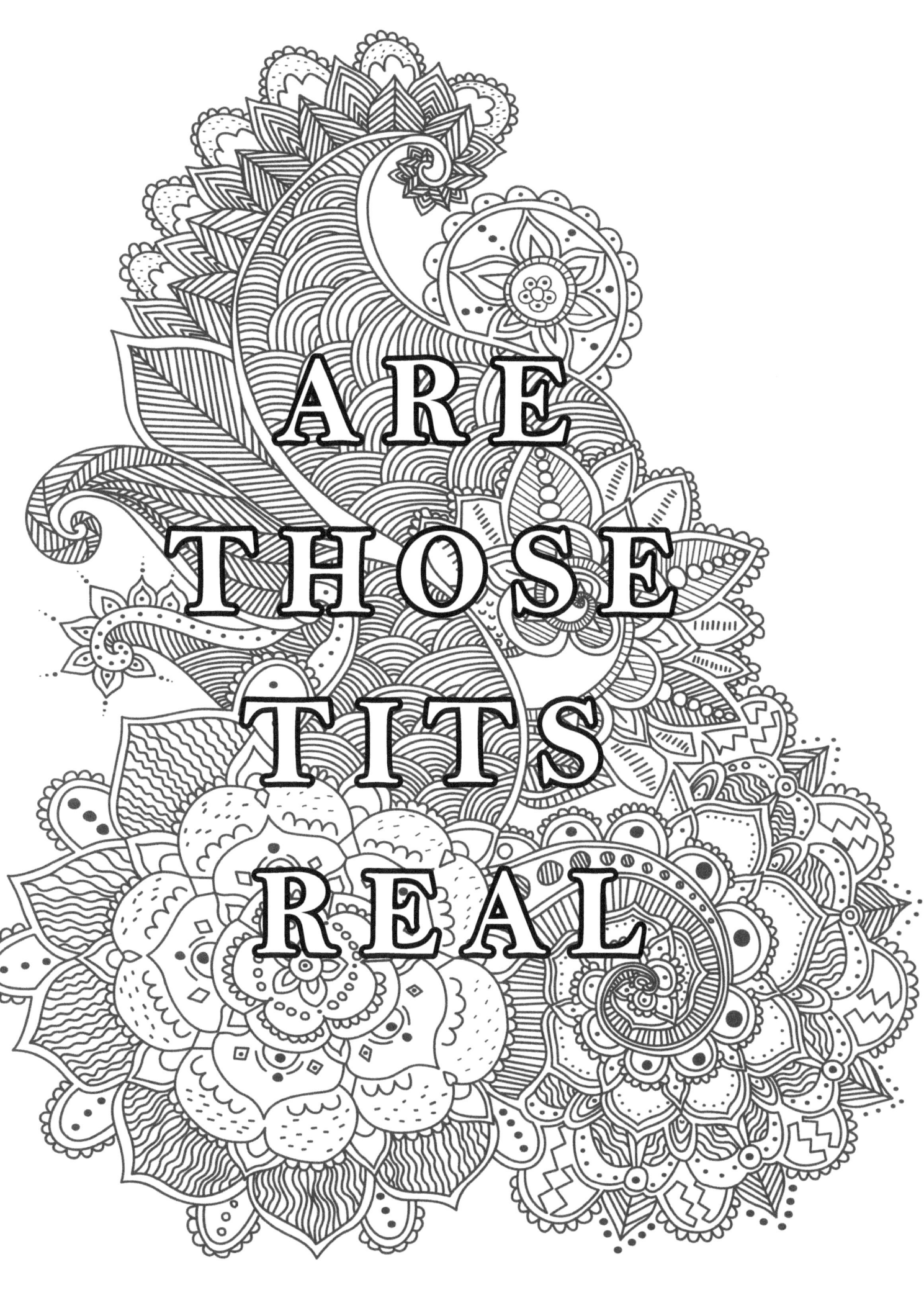

This is a Bleed Through Page If You Are Using a Coloring Marker or Pen!
Find Other Great Titles By Us. Search on Your Favorite Book Retailer
Just search for the author name of Woodrow Guy .
He also Publishes Lite Erotica on Amazon Kindle
CHECK OUT OUR WEBSITE FOR ALL OUR ADULT CREATIONS
WWW.WOODROWGUY.COM

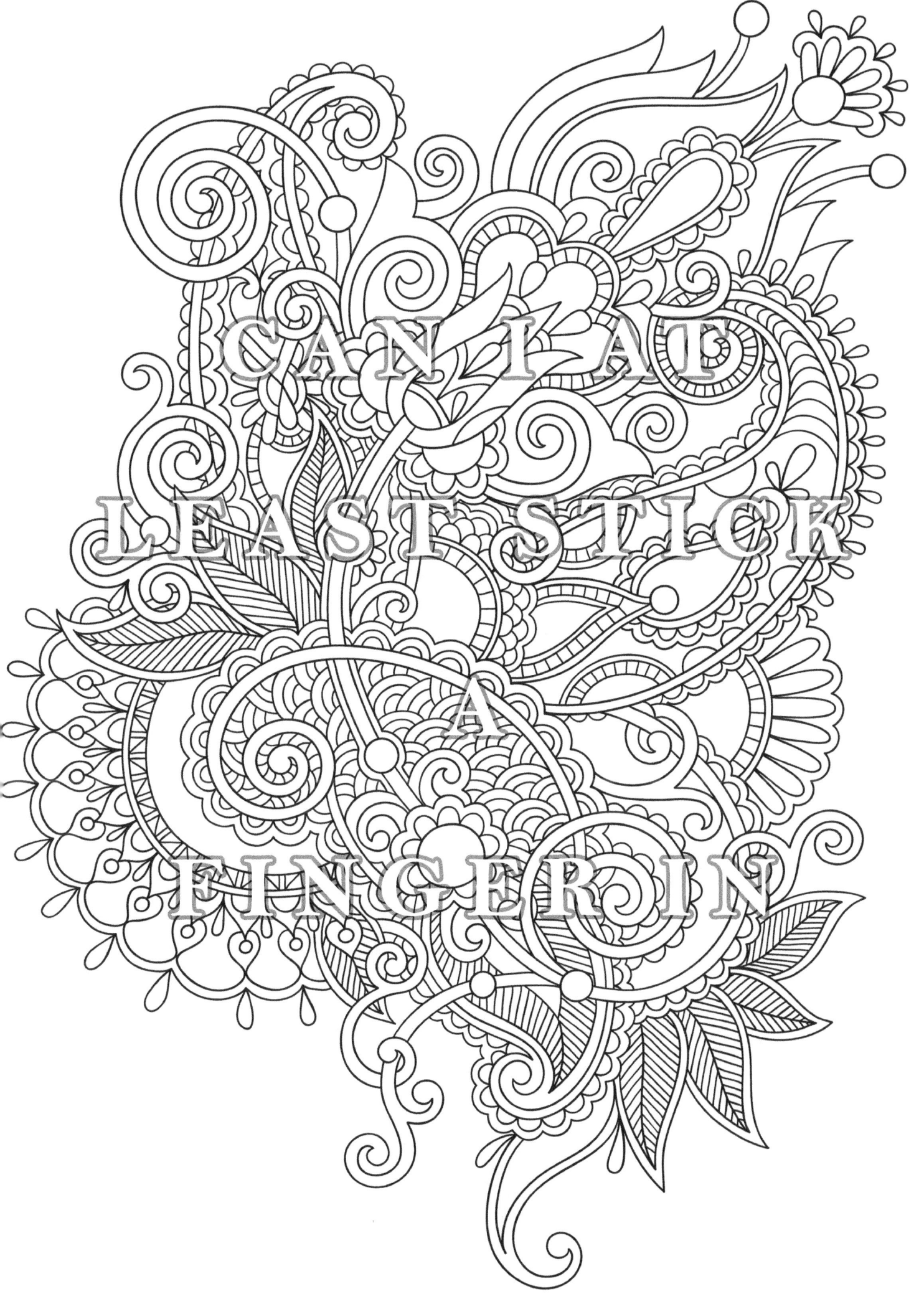

This is a Bleed Through Page If You Are Using a Coloring Marker or Pen!
Find Other Great Titles By Us. Search on Your Favorite Book Retailer
Just search for the author name of Woodrow Guy .
He also Publishes Lite Erotica on Amazon Kindle
**CHECK OUT OUR WEBSITE FOR ALL OUR ADULT CREATIONS
WWW.WOODROWGUY.COM**

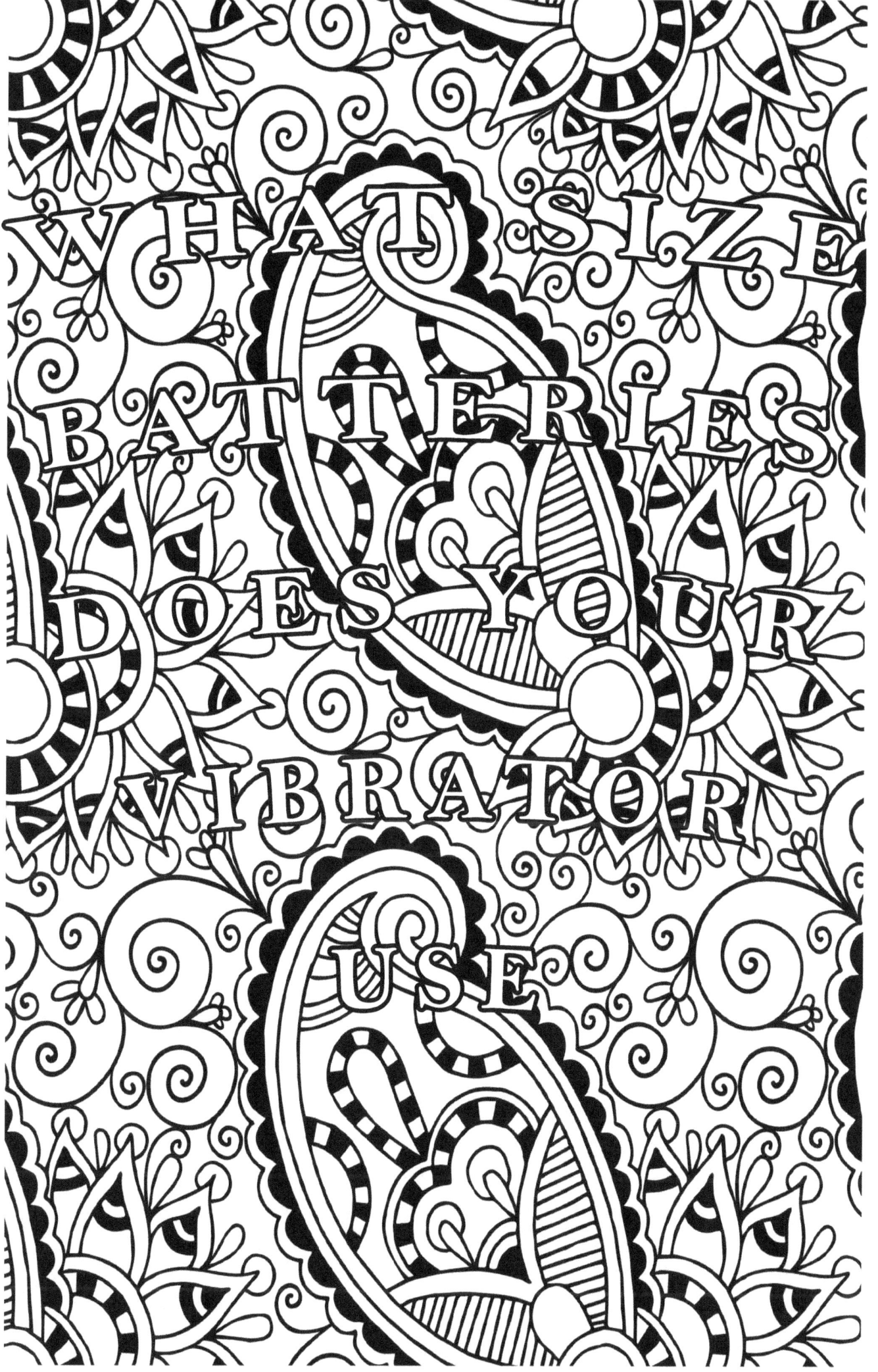

This is a Bleed Through Page If You Are Using a Coloring Marker or Pen!
Find Other Great Titles By Us. Search on Your Favorite Book Retailer
Just search for the author name of Woodrow Guy .
He also Publishes Lite Erotica on Amazon Kindle
**CHECK OUT OUR WEBSITE FOR ALL OUR ADULT CREATIONS
WWW.WOODROWGUY.COM**